JASON D'AQUINO'S

CIRCUS

INTRODUCTION BY KIRSTEN ANDERSON

PUBLISHED BY READ LEAF

Published in 2010 by Read Leaf
an imprint of Simply Read Books Inc.
www.simplyreadbooks.com

Text and Illustrations Copyright © 2010 Jason D'Aquino
www.jasondaquino.com

Introduction Copyright © 2010 Kirsten Anderson

Cataloguing in Publication Data

D'Aquino, Jason
 Jason D'Aquino's circus ABC / introduction, Kirsten Anderson.

ISBN 978-1-897476-25-3

 1. D'Aquino, Jason. 2. Alphabet in art. I. Title. II. Title: Circus ABC.

NC139.D36A4 2009 741.971 C2009-901959-0

Book Design by Mark Cox with Amy Stella

10 9 8 7 6 5 4 3 2 1

Printed in Singapore

STEP RIGHT UP! What you now hold in your hands is a fairly wondrous piece of alphabetery, a illustrated guide to the ABC's starring an amazing assortment of arcane animals, madcap marvels, and marvelous men and women of the midway.

Your host, miniaturist Mr. Jason D'Aquino, has scoured high and low to bring you these delightful images from lands far and near. Using only a super-sharp pencil and a magnifying glass, D'Aquino spends hours huddled over his desk creating his lovingly crafted, ultra-precise, and meticulously rendered graphite confections on vintage paper found in dusty bookstores and antique shops. All drawings are hand drawn and usually no larger than a postage stamp! No chicanery, no Photoshop, absolutely genuine.

These ABC's are mainly based of early 20th century circus and carnival acts and personalities. While they hail from another era, circus imagery has become so much a part of mainstream pop culture that most images will be instantly identifiable. True fans of carnival culture will recognize a few portraits of notables such as Nellie Keeler, P. T. Barnum's pretty petite princess famed for her delicate fairy-like beauty, as well as more than a few visual puns thrown in for good measure. For example, topping the bill is O for Originality featuring "The Great Omi - The Zebra Man," one of the world's most famous "tattooed men," and G is for Grin but also for Gacy, as in notorious serial killer and children's party clown John Wayne Gacy, who has only furthered the effects of coulrophobia among our younger, more tender citizens. Perhaps a more delightful example would be E for Extraordinary, featuring Johnny Eck, "King of the Freaks," who brought his "half-man" act to the thousands, but also led an exceptional life where his condition was no impediment to anything he felt like doing.

This book and its denizens are meant to celebrate the lives of those who walk outside the mainstream and have allowed us a fascinating glimpse into a magical world of fantasy and illusion.

Please enjoy!

Kirsten Anderson
Seattle, WA, 2010

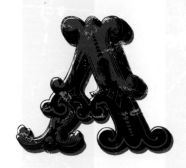

is for

ATTRACTION

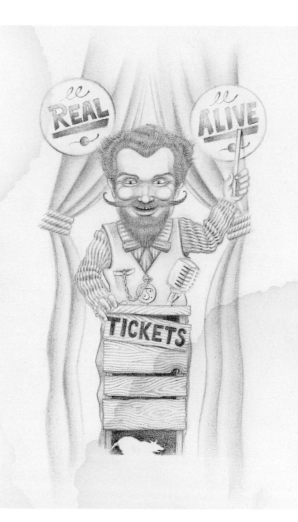

is for

BARKER

is for

CONEY

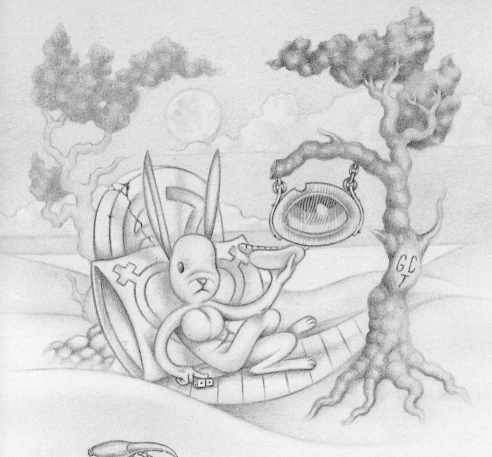

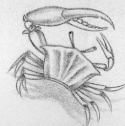

SEP 1,1609

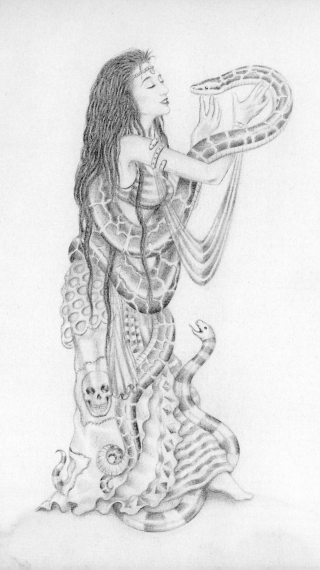

is for

DANGEROUS

is for

EXTRAORDINARY

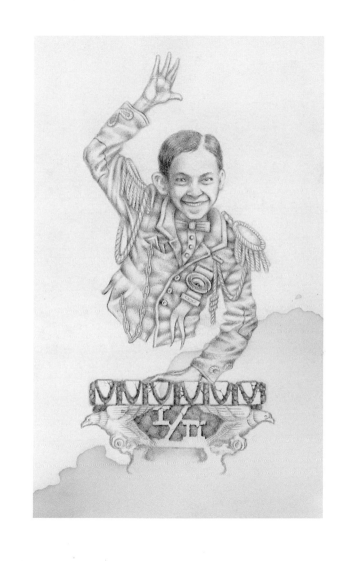

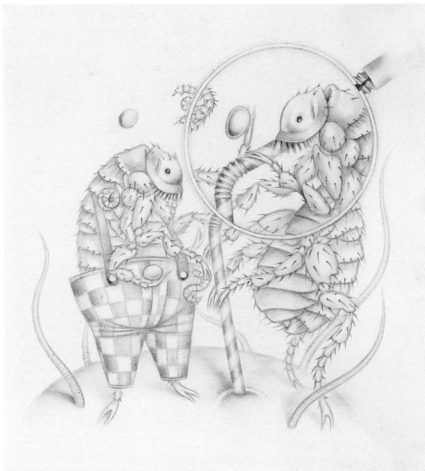

is for

FLEA CIRCUS

is for

GRIN

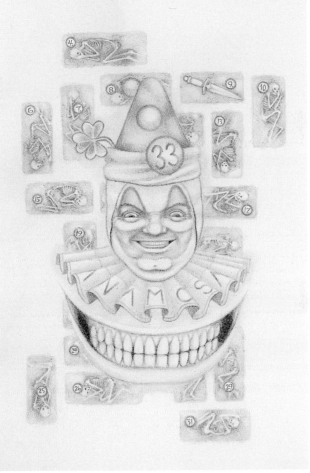

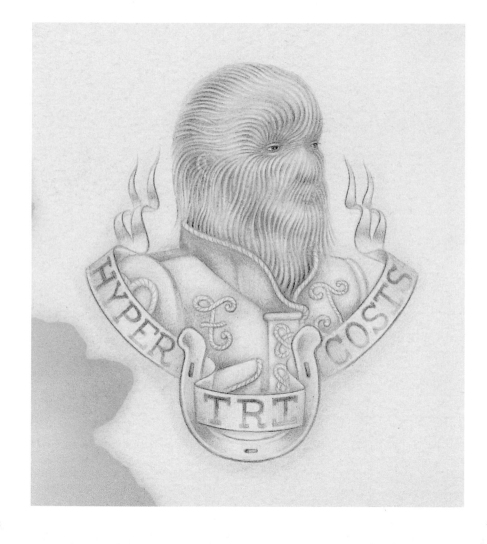

is for

HAIRY

is for

INSEPARABLE

is for

JUMBO

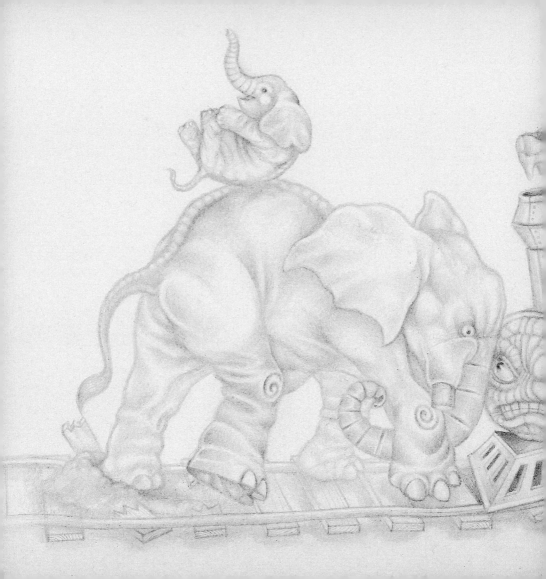

is for

KEELER

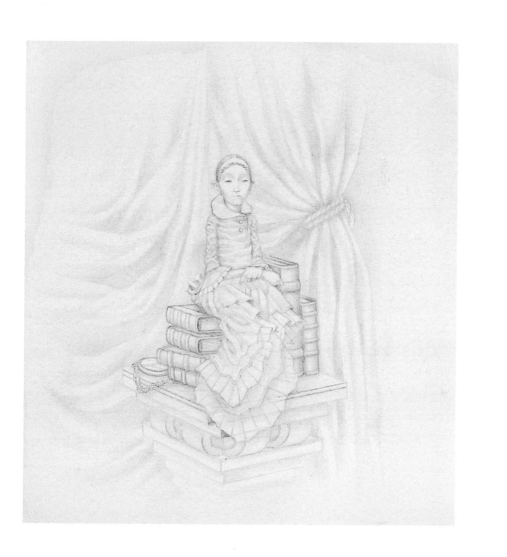

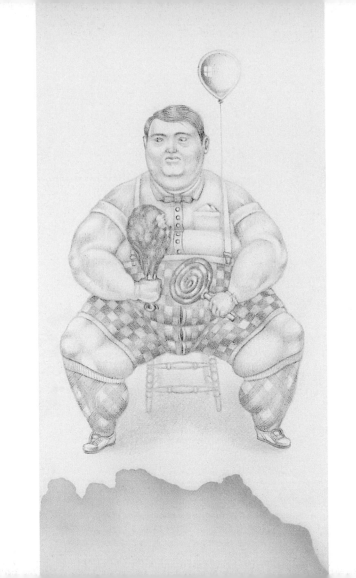

is for

LARGE

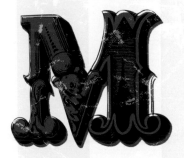

is for

MAGIC

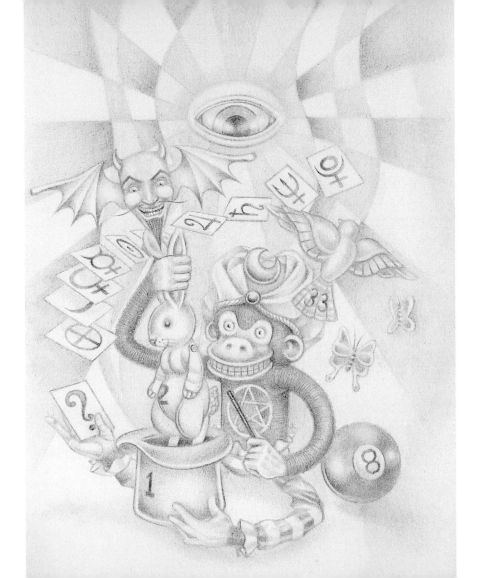

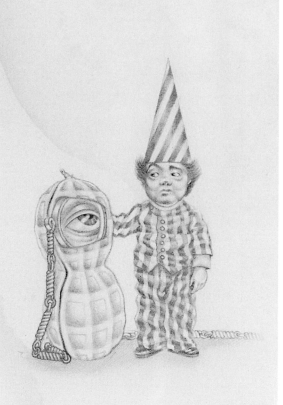

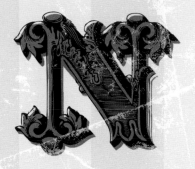

is for

NUTT

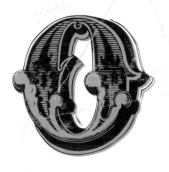

is for

ORIGINALITY

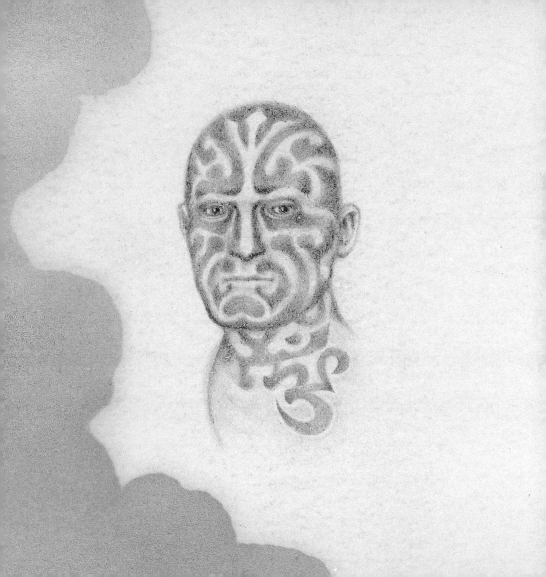

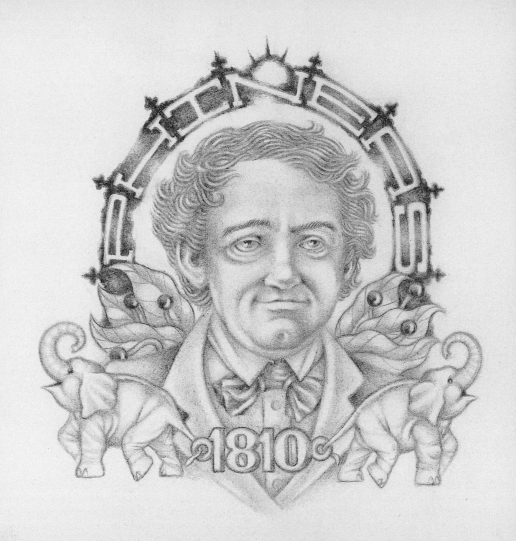

is for

PRANKSTER

is for

QUESTIONABLE

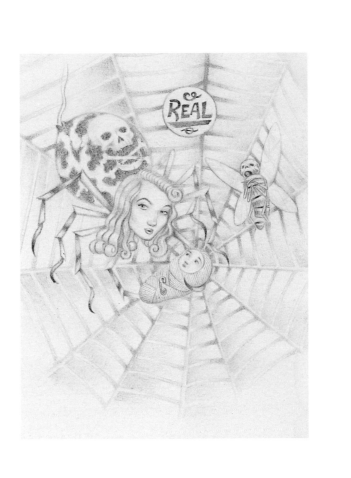

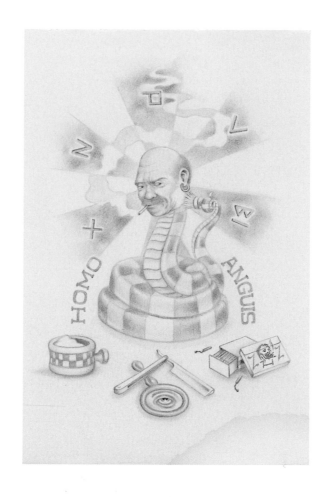

is for

REPTILE

is for

SHELLFISH

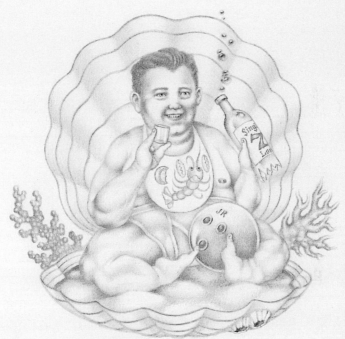

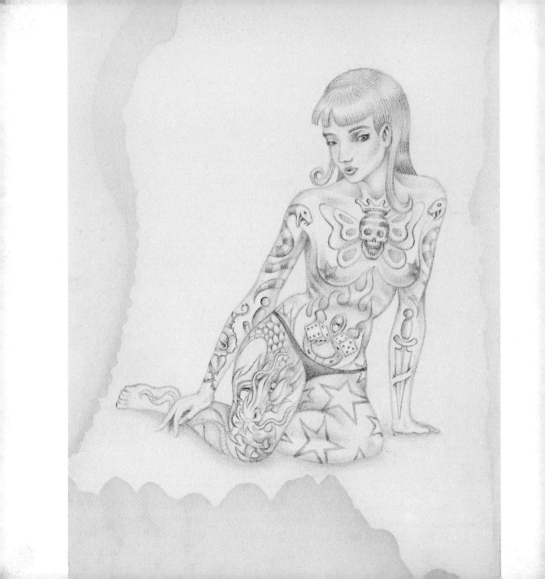

is for

TATTOOED

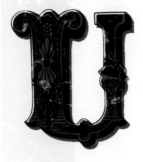

is for

UBANGI

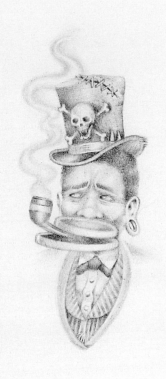

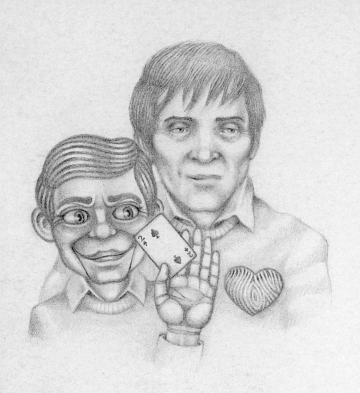

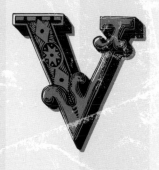

is for

VENTRILOQUIST

is for

WILD

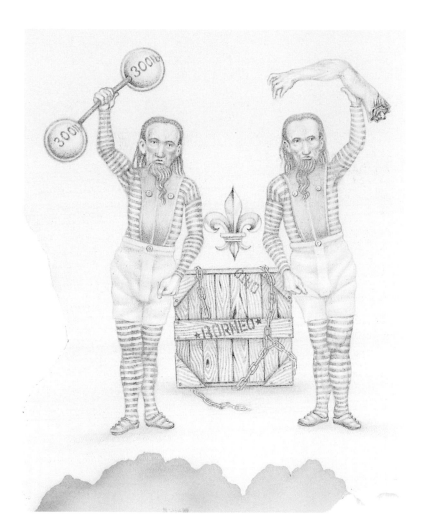

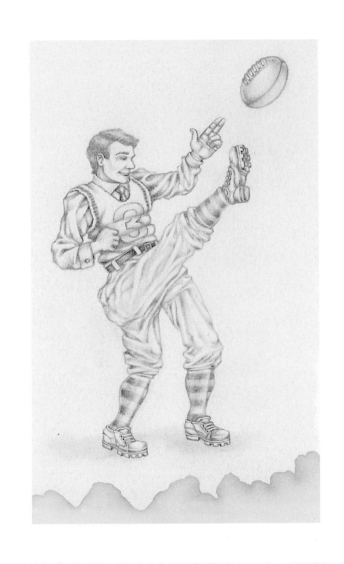

is for

X-TRA

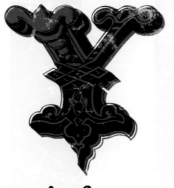

is for

YUMMY

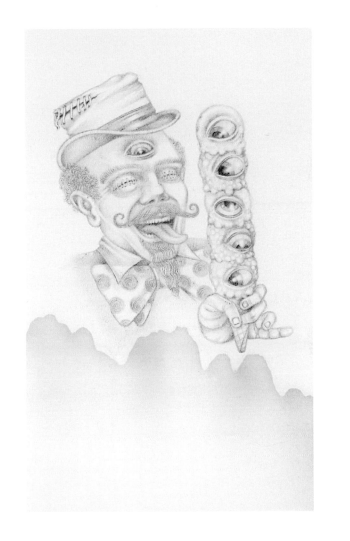

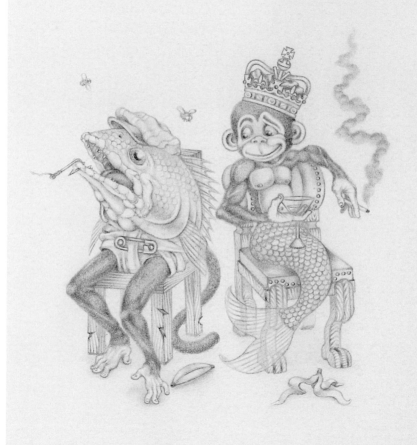

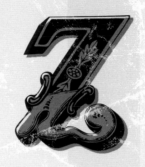

is for

ZOOLOGICAL
CONGLOMERATIONS

Like the work of artists such as Edward Gorey and writers such as Lemony Snicket, **JASON D'AQUINO**'s art is clearly influenced by the darker side of childhood, focusing on the wickedly humorous, gleefully gross, and the magically macabre rather than the warm and carefree.

D'Aquino's exceptional drawings have appeared in numerous galleries and influential collections across the United States, and he also has a thriving career as a tattoo artist in New York.

You can visit his website at **www.jasondaquino.com**